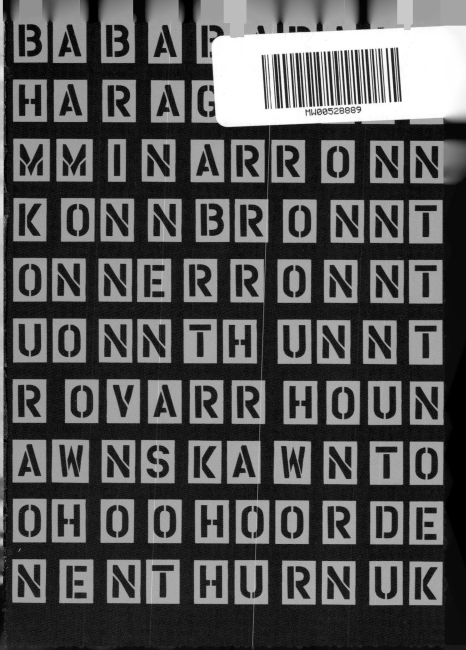

Mark Twain defined a classic book as one that everybody wants to have read but nobody wants to read. The few lines from Joyce's *Finnegans Wake* that you just read (did you?) clinch Twain's point. Actually, they are not a few lines but the first of ten key words in the *Wake*.

Here is the tenth one:

The first word (a bit later we'll get to justifying the outrageous claim that this is a word) has 100 letters and the second 101. That part's easy—and so is a lot more when we find the keys to turning Joyce's classics into books we want to read—from *spark to phoenish* (Joyce's pun).

"The keys to. Given!

A way a lone a last a loved a long the"

— last line of *Finnegans Wake*

EVERYMAN's
JOYCE

by W. Terrence Gordon
Eri Hamaji & Jacob Albert

MARK BATTY PUBLISHER
New York City

> BIOGRAPHY

Born in Dublin, on February 2, 1882, to John Stanislaus Joyce and his wife Mary Jane Murray, James Joyce began his education at age six under Jesuit scholars at Clongowes Wood College in County Kildare, continuing at Belvedere College in Dublin from 1893 to 1897. The following year, he entered the University College, Dublin, where he studied philosophy and languages, graduating in 1902.

At age eighteen, he published an essay on Henrik Ibsen's drama *When We Dead Awaken*, which appeared in the *Fortnightly Review* in 1900.

Joyce left Ireland for Paris in 1902, planning to attend medical school but spent most of his time writing.

On learning that his mother was dying, he returned to Dublin in 1903, but he was not to stay in his native land for long. Soon after Joyce met Nora Barnacle of Galway in 1904, the couple left for the Continent. Their union produced a son and a daughter; Joyce and Nora were eventually married in 1931.

At the beginning of World War I, Joyce and his young family began a series of moves, first to Zürich, where he began to work on *Ulysses*. By the time the work appeared in print in 1922, Joyce had already published *Dubliners* in 1914, *A Portrait of the Artist as a Young Man* in 1916 and the play *Exiles* in 1918. A collection of poems, *Chamber Music*, had appeared in 1907 and a second, *Pomes Penyeach*, would appear in 1927.

Within a year of the appearance of *Ulysses*—the book was plagued by censorship in Great Britain and the United States, where it remained contraband until 1933—Joyce, by then living in Paris, began writing *Finnegans Wake*. He was suffering from glaucoma, and chronic eye trouble dogged him for the rest of his days. The first segment of the *Wake* appeared in the *Transatlantic Review* in April 1924, under the title "Work in Progress." The final version of the work was published in 1939.

Acclaimed a masterpiece by many from the outset, the *Wake* found just as many readers ready to condemn it. When France fell to the Nazis, Joyce removed his family to Zürich once again. Weakened by illness and discouraged at the public reception of *Finnegans Wake*, he died there on January 13, 1941.

> WHO WERE JOYCE'S FAVORITE READS?

He had to concede that "the Englishman" was pretty good. (Remember that Joyce lived and died before it was first suggested that Shakespeare was a transplanted Italian named Crollalanza—literally "shake spear"—but this is another story.)

No surprise, given how Joyce the wordsmith worked, that he was particularly fond of The Bard's puns. There are may references to Shakespeare in *Ulysses* and literally hundreds more in *Finnegans Wake* (some of them included in the Encyclopedictionary at the end of this book).

But as a dramatist, Joyce opined, Shakespeare couldn't hold a candle to Henrik Ibsen. The great Norwegian author won Joyce's praise because his plays tackled the problems of modern society head on.

Apart from Ibsen, the only other writers whose works Joyce devoured completely were Ben Jonson, Daniel Defoe and Gustav Flaubert.

He said he loved Dante almost as much as the Bible.

To Homer,

Joyce gave the credit for using ordinary words and giving them extraordinary meanings.

(Who would not say the same of Joyce himself?)

Joyce admired

Chaucer's precision,
Yeats's symbolism,
Tolstoy's mastery of the novel form, and

Chekhov for scrapping the convention of drama
structured with

beginning mid

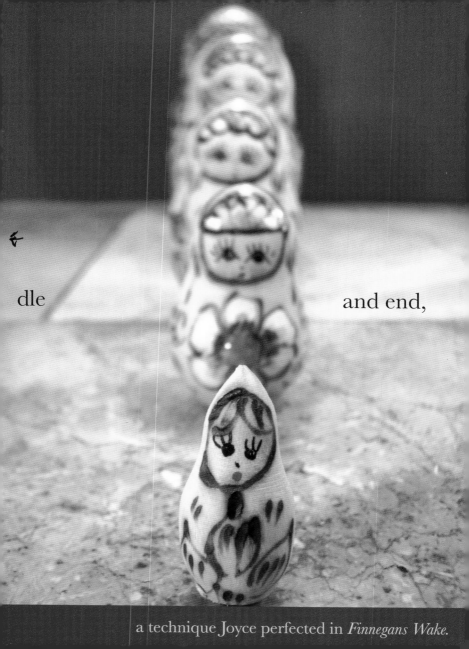

dle

and end,

a technique Joyce perfected in *Finnegans Wake*.

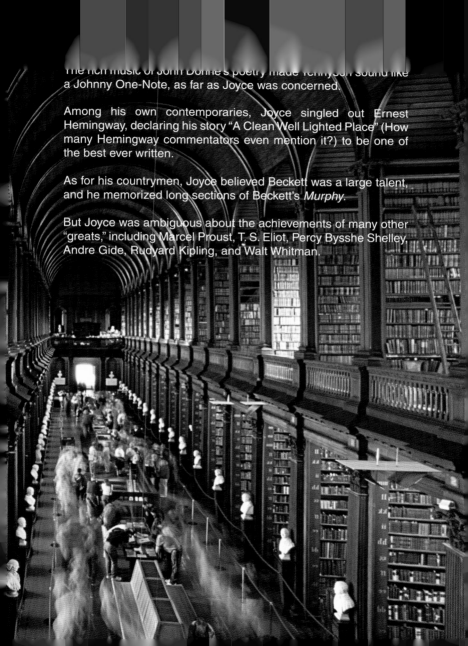

The rich music of John Donne's poetry made Tennyson sound like a Johnny One-Note, as far as Joyce was concerned.

Among his own contemporaries, Joyce singled out Ernest Hemingway, declaring his story "A Clean Well Lighted Place" (How many Hemingway commentators even mention it?) to be one of the best ever written.

As for his countrymen, Joyce believed Beckett was a large talent, and he memorized long sections of Beckett's *Murphy*.

But Joyce was ambiguous about the achievements of many other "greats," including Marcel Proust, T. S. Eliot, Percy Bysshe Shelley, Andre Gide, Rudyard Kipling, and Walt Whitman.

Joyce had a fondness for the illuminated manuscripts
of Golden Age Ireland, created between the sixth century
and the ninth century CE.

Speaking of his favorite, the magnificent gospel book
known as the *Book of Kells*, Joyce said that
much of his own work could be compared to
its intricate illuminations.

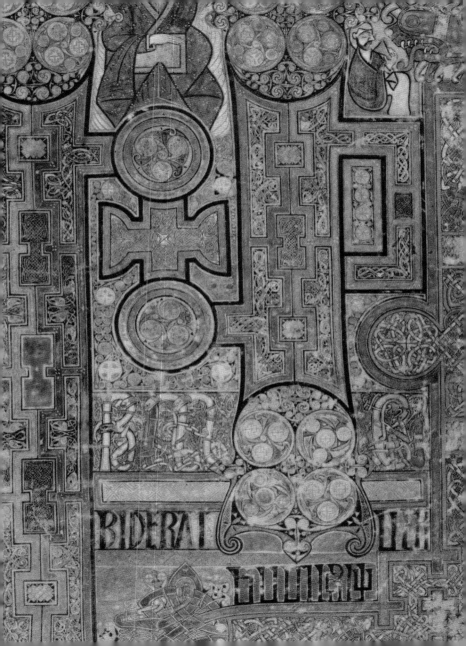

R And his derry's
own drawl and
his corkscrew blather
and his doubling stutter
and his gullaway swank.

seve. and of he.

'Huges Cabut Earlyfouler!'

∧ '=

1.14 C

O tell me all about Anna Livia! I want to hear all
about Anna Livia. Well, you know Anna Livia? Yes,
of course, we all know Anna Livia. Tell me all. Tell me
now. You'll die when you hear. Well, you know, when
the old chap went futt and did what you know. Yes,
I know, go on. Wash away and don't be dabbling. Tuck up
your sleeves and loosen your talktapes. Or whatever it was
they try to make out he tried to do in the Fiendish park. He's
an awful old rep. Look at the shirt of him! Look at the dirt
of it! He has all my water black on me. And it steeping
and stuping since this time last week. How many times is
it I wonder I washed it? I know by heart the places he likes
to soil. Scorching my hand and starving my famine to make
his private linen public. Wallop it well with your battle
and clean it. My wrists are rusty rubbing the mouldaw
stains. And the dneepers of wet and the gangres of sin in it!
What was it he did a tail at all on Animal Sunday? And how
long was he under lough and neagh. It was put in the papers
what he did, illysus distilling and all. But time will tell. I
know it will. Time and tide will wash for no man. O, the old
old rep! And the cut of him! And the strut of him! How he
used to hold his head as high as a howeth, the famous old
duke alien, with a hump of grandeur on him like a walking
rat. What age is he at all at all? Or where was he born or
how was he found and were him and her ever spliced? I
heard he dug good tin with his doll when he brought her home,
Sabine asthore, in a parakeet's cage, the quaggy way for
stumbling. Who sold you that jackalantern's tale? In a
gabbard he landed, the boat of life, and he loosed two croa-
kers from under his tilt, the old Phenician rover. By the

∧ Was her banns never loosened in Adam
 and Eve's and

R how the
 harbourless
 wenikan

F nicies and priers,
 King fierceas Humphrey, with

He wanted it to be possible for readers
to look at any page of his work
and know immediately what book it was from.

He got his wish.

> Putting English to sleep

D. H. Lawrence read Joyce's "Work in Progress" before it became *Finnegans Wake* and found nothing but "old fags and cabbage-stumps of quotations" that had been "stewed in the juice of deliberate journalistic dirty-mindedness."

Another literary giant, Vladimir Nabokov, dismissed the *Wake* as "a formless and dull mass of phony folklore."

And Carlos Fuentes declared Joyce to be a "black Irishman, wreaking a vengeance, even wilder than the IRA's on the English language."

On a more sober and thoughtful note,
Anthony Burgess declared that

Joyce put English to sleep in order to wake it up.

Such are the judgments of writers;
What about visual artists?

Picasso merely shrugged and declined the invitation
to illustrate an edition of *Ulysses*,
dismissing Joyce as an obscure writer that
all the world can understand.

Can, not *does*.

> **LANGUAGE LESSONS:**
> Traduced into jinglish janglage...
> *Finnegans Wake*, 275

Joyce was a linguist. (It was Shakespeare who coined this term for a person skilled in languages.) Joyce never boasted about his superb command of many languages, and though he provided help to translators of his own work, he may have never used the word "linguistics." If he did, it might have come out as a pun:

linktwistics.

This is just what Joyce does—twists the links between form and meaning—and forges new links among languages. He rubs linguistic sticks together to start a pentecostal fire. ✗

English, French, Italian, German, Latin, Danish, Gaelic, and many more come to the conflagration. ✦

Here are some samples of the French words lurking in the *Wake*.

What clashes here of wills gen wonts, oystrygods gaggin fishy-gods! Brékkek Kékkek Kékkek Kékkek! Kóax Kóax Kóax! Ualu Ualu Ualu! Quaouauh! Where the Baddelaries partisans are still out to mathmaster Malachus Micgranes and the Verdons

cata-pelting the camibalistics out of the Whoyteboyce of Hoodie Head. Assiegates and boomeringstroms. Sod's brood, be me fear! Sanglorians, save! Arms apeal with larms, appalling. Killykill-killy: a toll, a toll.

Among the first battlers (Baddelaries) named here are the Ostrogoths (oystrygods) going up against (gaggin is a twisted link to German gegen) the Visigoths (fishygods), but Joyce has already begun hauling in a Trojan horse full of French words: badelaire being a type of sword with a curved blade.

Once the gates are open, there is no stopping him:

Micgranes masks migraine (grenade), larms conceals larmes (tears)—connected further on to pleures of bells (crying of bells), sanglorians combines sang, sanglot, sans gloire (blood, sob, without glory), apeal suggests appel (call), and assiegates hybridizes the idea of laying siege to the gates with an old French word for lance.

Now if you thought those oystrygods smelled fishy, don't let Latin get your goat, because it's all Greek here.

Well, almost all.

Latin me that,
my trinity scholard,
out of eure sanscreed,
into oure eryan.

Hircus Civis Eblanensis!

He had buckgoat paps on him...

Finnegans Wake, 215

What then
agentlike brought about
that tragoady thundersday
this municipal sin business?

Finnegans Wake, 5

How does that translate?

The first passage is *about* translation, the challenge of transla-
tion (*Latin me that*), with reference to European languages (*eure*),
Sanskrit (*sanscreed*), and Irish (*oure eryan*).

Our Irish because here HCE (see page 146) is Joyce's coun-
tryman and friend, Oliver St. John Gogarty, the model for Buck
Mulligan in *Ulysses*. He of the *buckgoat paps*. Which brings us by
a *hircus civis* to the goat of the second passage. And to Greek,
where *tragedy* means goat-song. (A long tale hangs therein.)

So, Joyce gives us *tragoady*.

gdeuyss

jeuyce

joehce

joice

joyce

Now comes the fish link.

joayss

Joyce knew the popular example of
the inconsistencies of English spelling
being illustrated by

g-h-o-t-i as a "logical" alternative to

f-i-s-h (*gh* pronounced as in *rough*, *o* as in *women*, ghoyste
and *ti* as in *nation*),

and he worked this in to the text of the *Wake*: djeoycse

Gee each
owe tea eye
smells fish.

Finnegans Wake, 299

Now it's not just

oystrygods gaggin fishygods

but

fishygods gaggin ghotigoats.

All this is enough to make a spell-checker self-destruct. Even as the resonances of Joyce's texts continue. The alternate echo of ghotigoats is Gogarty, and it is Gogarty's alter ego, Buck Mulligan, who alludes in the first chapter of *Ulysses* to the fishgods of Dundrum.

If, as the saying goes, Gerard Manley Hopkins drove the English language like a sports car, was it Joyce who blew the engine?

Not so.

He knew that with the invention of the phonetic alphabet, human language had fractured itself, and for this too he invented a pun in *Finnegans Wake*:

allforabit

Finnegans Wake, 19

Historically, "A" is not for apple but for ox. How so? Our alphabet, the Latin alphabet, comes from the Greek alphabet, and it comes in turn from ancient Proto-Sinaitic, where A/a was a stylized drawing of an ox. In Phoenician and Hebrew too, the alphabets begin with the sign of the ox (called aleph in Phoenician and aleph or aluph in Hebrew). The upright horns on the animal's head turned east by the time aleph came into Greek as alpha (α). Then the ox headed due south in the final stage of the transformation into Latin A.

The letter B began life as Proto-Sinaitic bayit (house) and continued as beth (house) in Phoenician and Hebrew, before becoming Greek beta (β). The straight lines of the original floor plan of the house were replaced by loops and curved lines, and, like alpha, beta wound up upside down.

But a far bigger change came along the way from Hebrew to Greek: loss of meanings. (Joyce, by contrast, put himself into the business of multiplying meanings.) Starting with Greek, the names of the letters of the alphabet refer only to themselves. No more ox, house, camel, door, or any of the other things whose shapes and names make up the bits and pieces of the older alphabets.

This was a huge change that gave the new alphabet ($\alpha + \beta$) tremendous power. All the visual reminders of oxen, houses, etc., disappeared, and the whole focus of the alphabet shifted to language itself. On the one hand, all the associations of meaning for the objects originally linked to letter names were eliminated—traded in, for nothing more than the sound at the beginning of the names of those objects (all for a bit). On the other hand, that left the new sound-letters free to combine with each other in any number of ways to create new meaning (*all for a bit*).

Joyce broke into print at age nine, when he wrote "Et Tu Healy," on the death of Charles Parnell. Sometimes referred to as the uncrowned king of Ireland, Parnell championed the cause of Irish Home Rule. Joyce's father, angry over the treatment Parnell received at the hands of the Catholic Church and the defeat of the Home Rule movement, but proud of his eldest son's literary effort, had the poem printed and a copy deposited at the Vatican Library.

Chamber Music

Joyce's first volume of poetry appeared in print in 1907. When Leopold Bloom says "Chamber music. Could make a pun on that," he's thinking of the tinkling in a chamber pot. That puts the poetry in the pot and sheds a new light on Joyce's remark about the title. He was dissatisfied with it as soon as the book appeared, saying that he would have preferred a title that repudiated the book without dissing it. If Joyce had not made Bloom hold his tongue, he might have come up with Potty Music, Potted Poetry, or even a harbinger of Joyce's later volume, *Pomes Penyeach: Pomes Piddling Each*.

But there is nothing raucous or indelicate about the poetry of *Chamber Music*.

Joyce sent a pre-publication copy of his work to Yeats, who found this poem a bit thin. But when Yeats showed it to Ezra Pound, who was prepared at once to pay for the rights to publish it in an anthology, Yeats revised his opinion, declaring the poem a technical and emotional masterpiece.

I hear an army charging upon the land,

And the thunder of horses plunging, foam about their knees:

Arrogant, in black armour, behind them stand,

Disdaining the reins, with fluttering whips, the charioteers.

They cry unto the night their battle-name:

I moan in sleep when I hear afar their whirling laughter.

They cleave the gloom of dreams, a blinding flame,

Clanging, clanging upon the heart as upon an anvil.

They come shaking in triumph their long, green hair:

They come out of the sea and run shouting by the shore.

My heart, have you no wisdom thus to despair?

My love, my love, my love, why have you left me alone?

Pomes Penyeach

Joyce's second volume of verse, though more slender than the first with just thirteen poems, did not appear until twenty years after the first edition of *Chamber Music*. But then Joyce had been busy with other matters...such as *Ulysses*.

Coming from a more mature artist than the poems of *Chamber Music*, those of *Pomes Penyeach* are less lyrical and marked by darker tones and heavier feelings. The work was published by Sylvia Beach's Shakespeare & Company in a first run of just fifty copies. At twelve pence or twelve francs a copy, readers received a baker's dozen of poems, like the apples (pommes) named in the title.

Collected Poems

1936 saw the publication of Joyce's *Collected Poems*. This volume brought "Ecce Puer" ("Behold the boy-child"), written in 1932, to the reading public for the first time. Written shortly after the death of Joyce's father and the birth of his grandson Stephen, it resonates with all the transparent emotions of the writer in his metamorphosis from son to grandfather.

Ecce Puer

Of the dark past
A child is born;
With joy and grief
My heart is torn.

Calm in his cradle
The living lies.
May love and mercy
Unclose his eyes!

Young life is breathed
On the glass;
The world that was not
Comes to pass.

A child is sleeping:
An old man gone.
O, father forsaken,
Forgive your son!

50

Collected Poems also includes "The Holy Office," a poem in which a very feisty—if not altogether venomous—Joyce takes aim at the hypocrisy of the Dublin of 1904 and serves up large dollops of unrestrained satire:

Thus I relieve their timid arses / Perform my office of Katharsis.

And the closing lines of another poem dating from 1912 are much in the same vein.

Gas from a Burner

This very next lent I will unbare
My penitent buttocks to the air
And sobbing beside my printing press
My awful sin I will confess.
My Irish foreman from Bannockburn
· Shall dip his right hand in the urn
And sign crisscross with reverent thumb
Memento homo upon my bum.

If we look for a link between Joyce's poetry and his prose writings, we discover it in the poem "Nightpiece" from *Pomes Penyeach*.

This poem occurs in an early draft of *Finnegans Wake*, and Joyce makes reference to it in a dream passage found in his journal, *Giacomo Joyce*. Written on January 22, 1915, during the Joyce family's sojourn in Trieste, "Nightpiece" was inspired, according to the journal entry, by a visit that Joyce had made to Notre Dame Cathedral in Paris on the occasion of Good Friday devotions.

Nightpiece

Gaunt in gloom,
The pale stars their torches
Enshrouded wave.
Ghostfires from heaven's far verges faint illume
Arches on soaring arches,
Night's sindark nave.

Seraphim
The lost hosts awaken
To service till
In moonless gloom each lapses, muted, dim
Raised when she has and shaken
Her thurible.

And long and loud
To night's nave upsoaring
A starknell tolls
As the bleak incense surges, cloud on cloud,
Voidward from the adoring
Waste of souls.

> **DUBLINERS**

Dubliners is not set in Leopold Bloom's Dublin of 1904. The fifteen stories take place a decade or two earlier. Ireland was then in thrall to the Irish Revival, but the memory of the Potato Famine was still fresh, and bitterness over the failure of the Home Rule Movement was strong. As a result, the stories of the *Dubliners* told by Joyce revolve around the themes of death and paralysis (of mind, body, spirit—the result of abandoned or thwarted ideals).

Less than a novel but more than a collection of short stories, because of its unifying elements, *Dubliners* is a moving book, and despite its dark themes, ranges from the serious to the comic, though without putting readers on a roller-coaster ride, as *Ulysses* and *Finnegans Wake* later would.

There was no hope...

These are the opening words of *Dubliners*. Both the first and last stories deal with death. In the former ("The Sisters"), it is a stark presence; in the latter ("The Dead"), it is a remembered death, not overshadowing but overshadowed by the lyricism of the final scene and the final words of the book:

His soul swooned slowly as he heard the snow falling faintly through the universe and faintly falling, like the descent of their last end, upon all the living and the dead.

If there was no hope for Father Flynn to survive his third stroke in "The Sisters," there is hope for the nameless young narrator of the story to emerge from the gloom, foreboding, and unsettling ambiguities surrounding the life of the dead priest:

I found it strange that neither I nor the day seemed in a mourning mood and I felt even annoyed at discovering in myself a sensation of freedom as if I had been freed from something by his death.

This will be the first step in his awakening, the first step in his metamorphosis into a Gabriel Conroy ("The Dead"), who understands the freedom that unifies the living and the dead.

One story after another in *Dubliners* tells of a failed quest. The boy in "An Encounter" plans to visit the Pigeon House without reaching his destination; the main character in Araby does reach the exotic bazaar of the story's title, but it is closing down when he arrives. Eveline's destination is Argentina, which she hopes will be a sanctuary from her violent father and her mother's "life of commonplace sacrifices closing in final craziness." Eveline idealizes the respect she will be given in Argentina, but in the end she is incapable of embarking on the voyage.

In "Two Gallants," Joyce introduces the characters Lenehan and Corley. Lenehan will reappear in six different episodes of *Ulysses*, while Corley returns in one. No less than twenty other characters from *Dubliners* also reappear in the pages of *Ulysses*.

Joyce gives coherence to *Dubliners* through his use of symbolism.

In "Two Gallants," the harp, an ancient emblem of Ireland, retains that value. The double halo of the moon reminds readers that neither Lenehan nor Corley is a saint, and that the woman in blue and white, though clad in the traditional colors of the Virgin Mary, is no virgin. And Joyce's preferred colors to symbolize decay, yellow and brown, return in the conclusion to "Two Gallants," where the coin the young woman steals is yellow.

> A Portrait of the Artist as a Young Man

A Portrait of the Artist as a Young Man is a self-portrait of the artist and a latent portrait of the art to come. Joyce's thinly veiled auto-biography takes Stephen Dedalus from: "a nicens little boy named baby tuckoo" (P 3) to an emboldened young man, apostrophizing life:

X *I go to encounter for the millionth time the reality of experience and to forge in the smithy of my soul the uncreated conscience of my race.*

A Portrait of the Artist as a Young Man, 275-76

Never one to let go of a word without mining it and miming it, even in this early work, Joyce's splay of signifiers moves from nicens through a string of nice's:

nice expression
nice mother
nice and warm
it would be nice

including

not so nice

...all of them framing the introduction of Stephen's school unchum, Nasty Roche.

58

The technique is simple and subtle at the same time. Nowhere in the pages of *Portrait* does Joyce trick readers into believing that they must hang onto his code-tails for dear life, as he will in *Ulysses* and the *Wake*. (It's a trick on Joyce's part because the trick that readers must learn is to "get it" by letting go.) Much of the early Joyce has the feel of early Gertrude Stein (*Three Lives*): lean and clean sentences hewn from solid English. He had yet to invent the language that Anthony Burgess would later call Eurish, the Joycean invention that Stein found so repugnant.

The nice/nasty-type figure is one that Joyce favors but with many variations throughout *Portrait*. Stephen is incubating a fever when Joyce writes:

*To remember that and the white look of the lavatory made him feel cold and then hot. There were two cocks that you turned and water came out: cold and hot. He felt cold and then a little hot: and he could see the names printed on the cocks. That was a very queer thing. (*A Portrait of the Artist as a Young Man*, 8)*

If Joyce makes fewer demands of readers in *Portrait* than in his later works, the text is no less rich or dense. The passage below, condensed from two pages of one of Stephen's many interior monologues, illustrates the point. The complete text begins with a subtle pun on augury, originally meaning the practice of foretelling the future from the flight of birds, with the word soon morphing into augur. But even by then the passage has moved quickly into Swedenborgian philosophy, and is about to soar into reflections on Stephen's own family name (in Greek mythology, Daedalus plunged into the sea and drowned when the wax he had used to attach wings to his back melted as he soared toward the sun), a dash of humor, meditation on language inspired by lines cited from Yeats, and much lyricism, before the ear of memory is defeated by jaded eyes.

Or is it?

Why was he gazing upwards from the steps of the porch, hearing their shrill twofold cry? For an augury of good or evil? A phrase of Cornelius Agrippa flew through his mind and then there flew hither and thither shapeless thoughts from Swedenborg on the correspondence of birds to things of the intellect... A sense of fear of the unknown moved in the heart of his weariness, a fear of symbols and portents, of the hawklike man whose name he bore, soaring out of his captivity on osierwoven wings, of Thoth, the god of writers... He smiled as he thought of the god's image for it made him think of a bottlenosed judge in a wig... What birds were they?... they were birds ever going and coming, building ever an unlasting home... A soft liquid joy like the noise of many waters flowed over his memory and he felt in his heart the soft peace of silent spaces of fading tenuous sky above the waters, of oceanic silence... A soft liquid joy flowed through the words where the soft long vowels hurtled noiselessly and fell away, lapping and flowing back and ever shaking the white bells of their waves... and he felt that the augury he had sought in the wheeling darting birds... had come forth from his heart like a bird from a turret quietly and swiftly. Symbol of departure or of loneliness? The verses crooned in the ear of his memory before his remembering eyes... He was alone at the side of the balcony, looking out of jaded eyes at the culture of Dublin in the stalls and at the tawdry scene-cloths and human dolls framed by the garish lamps...

A Portrait of the Artist as a Young Man, 244-45

The voice of Stephen; the voice of Joyce. Amid the fragments of songs, verses, and rhymes that crowd the opening pages of *Portrait*, we do not learn baby tuckoo's first word; when Stephen speaks for the first time, it is to say his own name. But at this point the book is a third-person narrative, as it will remain except for a few closing pages, where Stephen's reported "I"s are replaced by his reporting eyes. Even there Stephen does not step in as narrator; instead Joyce opens the pages of Stephen's diary for us at the moment of his epiphany and departure from Dublin.

Throughout the book it is Stephen's friend Cranly whose questions have helped Stephen to understand himself. In the end, when Cranly cannot answer Stephen's question

Of whom are you speaking?
(A Portrait of the Artist as a Young Man, 269)

it is Stephen who must speak to bring the book to a close. And he can speak because of the sudden insight that compelled him to put the question to Cranly:

He had spoken of his own self, of his own loneliness which he had feared.
(A Portrait of the Artist as a Young Man, 269)

Just as Stephen, departing for the continent, finds his voice, the voice needed to fill the void left by Cranly's silence, Joyce begins his own voyage toward *Finnegans Wake* via the commodius vicus of *Ulysses*.

Without wandering and without heeding siren calls, he steers a steady course toward the discovery of a voice that will make the *Wake* a dream.

> EXILES

If Joyce wrote any plays other than *Exiles*, they have not survived or not been found. Though preoccupied with completing *A Portrait of the Artist as a Young Man*, and already pondering *Ulysses*, Joyce was pulled back to his interest in drama—and particularly Ibsen—whose influence resonates throughout the pages of *Exiles*. The play is driven by the tensions created when the ideals of the characters clash with their passions.

When Robert makes advances on Bertha, the common-law wife of unfaithful Richard, it is only through jealousy over Richard's obvious attraction to Beatrice that Bertha reveals to her husband what his old friend is up to. Reacting to the revelation with what might seem to be suspect altruism, Richard urges Bertha to make full use of the freedom to follow her own desires. Bertha neither sees the inherent contradiction in Richard's advice to achieve freedom through submission nor does she foresee potential complications arising from heeding his words, because her real desire is to win his fidelity and hear him say that he needs her. For all the characters in the play conflicts around their ideas of freedom, how they exercise their own freedom, and what mutual expectations emerge from their actions combine as constant reminders that the wings of freedom are tangled by biological constraints on the human spirit.

Though we have no other plays by Joyce to serve as a context or point of comparison for *Exiles*, the title itself provides a link to a dominant theme in the rest of his work. Richard, freshly returned to Dublin as the play begins, is speaking of his mother as he explains why and how his nine-year sojourn in Rome with Bertha was a period of exile:

She drove me away. On account of her I lived years in exile and poverty too, or near it. I never accepted the doles she sent me through the bank. I waited, too, not for her death but for some understanding of me, her own son, her own flesh and blood; that never came (Act, I).

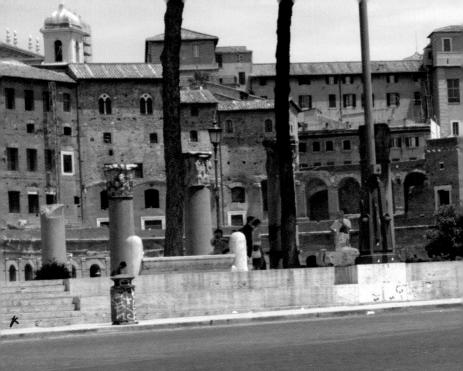

Like virtually every other figure from the young, unnamed
narrators in *Dubliners*, through Stephen Dedalus in *Portrait*
and *Ulysses*, to Humphrey Chimpden Earwicker in *Finnegans
Wake*, Richard, and all the principal characters of *Exiles*, are
alienated by

choice,
chance, or
circumstance,

...or a combination of all three.

> ULYSSES

The action of *Ulysses* takes place on 16 June 1904, a date now celebrated by Joyce devotees as Bloomsday and marked by reading events and festivals worldwide. In Dublin, the faithful retrace the steps of Leopold Bloom and the book's other characters, walking the same streets where Joyce too walked that day on his first date with Nora Barnacle.

The idea for the book started out as an idea for a story that Joyce intended to include in *The Dubliners*. But then he recognized it as a good fit for a sequel to his autobiographical novel Stephen Hero, eventually revised as *A Portrait of the Artist as a Young Man*, so that it could dovetail with *Ulysses* as a full-blown novel.

I took from the Odyssey the general outline, the "plan" in the architectural sense, or maybe more exactly, the way the fable unfolds, and I followed it faithfully, down to the tiniest detail...

— James Joyce

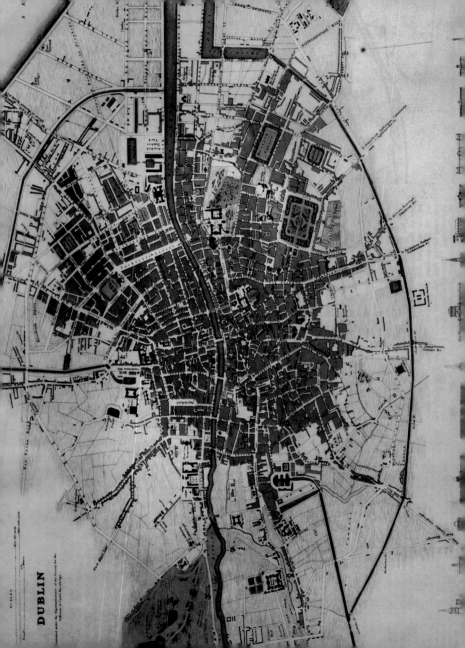

DUBLIN

Recognizing Leopold Bloom, his wife Molly, and Stephen Dedalus as
the stand-ins for Homer's *Odysseus* (his name becomes *Ulysses* in
Latin), Penelope, and Telemachus is easy.

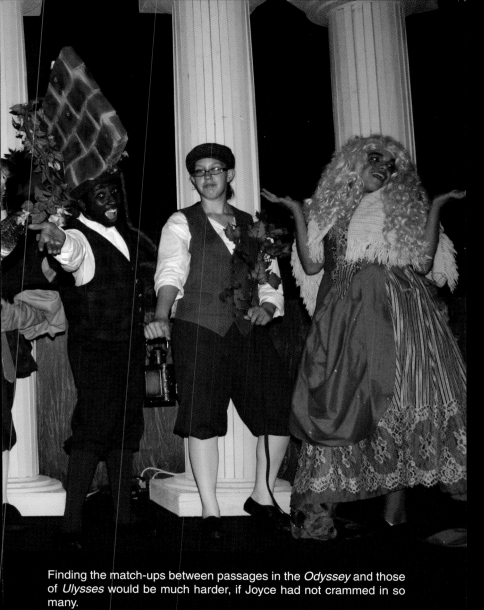

Finding the match-ups between passages in the *Odyssey* and those of *Ulysses* would be much harder, if Joyce had not crammed in so many.

This takes Bloom over one square mile of Dublin, whereas Ulysses wandered far and wide over land and sea in the ancient Mediterranean world. But right from the opening chapter of each work there are corresponding elements.

Joyce parallels Homer's invocation of the muse with the opening words of the Latin mass, *Introibo ad altare Dei* ("I will go up to God's altar"). It is Stephen's friend Buck Mulligan who speaks these words in a blasphemous parody on the first page of *Ulysses*.

The story of Agamemnon, murdered by his wife and her lover, is evoked by Homer as a dark warning of the fate that may befall Odysseus, and it too finds its counterpart in Joyce...but via Shakespeare. Stephen believes he has proven (by algebra!) that Hamlet's grandson is Shakespeare's grandfather and that Stephen himself is the ghost of his own father! Predictably, Buck ridicules Stephen over this. But their visitor, the Englishman Haines, cautions that Stephen—like Hamlet—could descend into madness, in a subtle counterpoint to Homer's omens for Odysseus.

Ulysses gets subtler and not so easy to decipher, unless we approach it ready to play the mind games that Joyce invented to tease readers. It's a good warm-up for reading *Finnegans Wake*, where things get even tougher. (As Joyce's compatriot Samuel Beckett said, when asked to comment on the *Wake*, it is not about something; it is that something itself.)

If we want it to be about something—one thing—we impoverish the text and ourselves, falling into the same trap as the students in the second episode of *Ulysses* (as the unnumbered chapters are commonly referred to), who are eager to hear the riddle Stephen offers them:

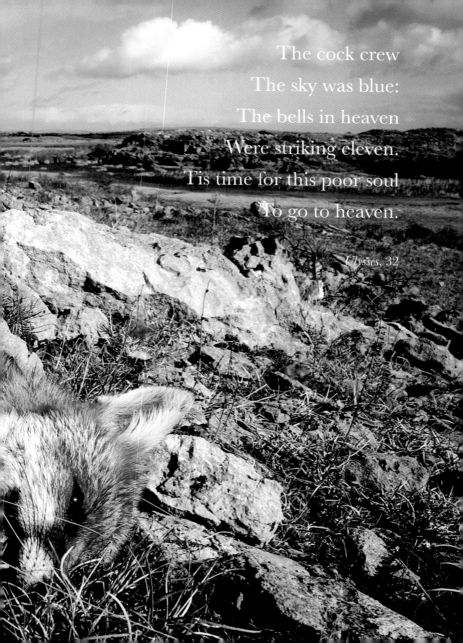

The cock crew
The sky was blue:
The bells in heaven
Were striking eleven.
Tis time for this poor soul
To go to heaven.

Ulysses, 32

The riddle is too much for boisterous schoolboys, and they quickly give up, crying What is it, sir? Stephen answers: The fox burying his grandmother under a hollybush. The boys are dismayed and quickly go off to play a game that is much easier to understand. Stephen has outfoxed them with a **deliberate disconnect between the riddle and its answer.** For readers, the game is not over. Much later in the text, when the hallucination of a foxhunt begins and a fox appears, we discover:

A stout fox drawn from a covert, brush pointed, having buried his grandmother, runs swift for the open, brighteyed, seeking badger earth, under the leaves.

Ulysses, 557

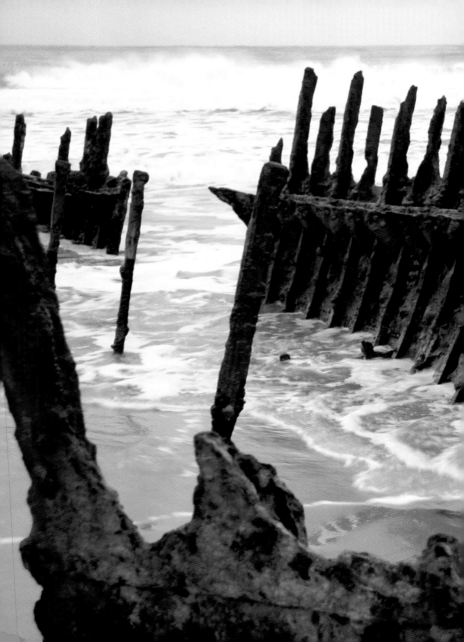

> Hitherandthithering Walkers

Reverie, reminiscence, and reflection on lofty questions
of philosophy wash over Stephen's mind as he strolls
along the strand in episode 3. If his wandering seems
aimless, his mind's eye sees its goal:

Signatures of all things I am here to read,
seaspawn and seawrack, the nearing tide,
that rusty boot.

Ulysses, 45

In less than a dozen lines of text,
he is moving toward a solution to the
Ineluctable modality of the visible (*Ulysses*, 45):

Shut your eyes and see *(Ulysses, 45)*

When he does, he hears his boots

crush crackling wrack and shells. *(Ulysses, 45)*

He discovers the

ineluctable modality of the audible *(Ulysses, 45)*

and is tempted to heed the voice
that tells him to open his eyes, until he realizes:

I am getting on nicely in the dark. *(Ulysses, 45)*

The line is a complex anticipation of a passage to come years later in *Finnegans Wake*:

In the buginning is the woid, in the muddle is the sound-dance, and thereinofter you're in the unbewised again, vund vulsyvolsy. (*Finnegans Wake*, 378)

Amid the ciphers of seaspawn and seawrack, Stephen's inner monologue ranges from the lyrical to the delirious—not altogether separable from each other—again reminiscent of the *Wake*:

Broken hoops on the shore; at the land a maze of dark cunning nets; farther away chalkscrawled backdoors and on the higher beach a dryingline with two crucified shirts. Ringsend: wigwams of brown steersmen and master mariners. Human shells. (*Ulysses*, 50)

But this is not the moment for Finnegan to begin again; *Ulysses* has barely begun, Bloom has yet to make his appearance. The prose descends into the prosaic (or lower):

He laid the dry snot picked from his nostril on a ledge of rock, carefully. For the rest, let look who will. (*Ulysses*, 64)

Here a reader can miss the challenge of facing the ineluctable modality of the visible, just as easily as Mr. Deasy missed the challenge of facing the ineluctable modality of the audible.

> Bloom in the Nickin' Time

Time never stands still in the narrative of *Ulysses*, but it does back up—once.

Episode 4 introduces Leopold Bloom of 7 Eccles Street. Here, across Dublin from the Sandy Bay Martello tower where Stephen breakfasts with Mulligan and Haines, Bloom prepares breakfast for himself and his wife Molly. We follow him from butcher shop to outhouse.

Scheme of Time

will follow him around Dublin on a commodiu
ore episodes with the focus on locus:

The Bath	10.00
The Graveyard	11.00
The Newspaper	12.00
The Lunch	13.00
The Library	14.00
The Streets	15.00
The Concert Room	16.00
The Tavern	17.00
The Rocks	20.00
The Hospital	22.00
The Brothel	24.00
The Shelter	1.00
The House	2.00
The Bed	

Who gave you that numb? (*Finnegans Wake*)

Poldy! (Short form of Leopold.)

This is Molly Bloom's name for her husband. Henry Flower is the pseudonym under which he receives a clandestine letter from a certain Martha Clifford. Kinch (meaning blade) is Buck Mulligan's nickname for Stephen, and Stephen Hero is the name that Joyce originally gave Stephen Dedalus.

Our heroes arrive at the newspaper office, Bloom to place an ad, Stephen to deliver a letter from Mr. Deasy, but they do not meet. It is only noon, but two hours later, they will both find themselves at the National Library. Stephen is expounding his biographical theory of the works of Shakespeare; Bloom has come to look at an exhibit of statues. Their paths do not cross. Though Bloom is unaware of Stephen's presence, Buck Mulligan is present, and when he sees Bloom he jokes with Stephen:

Did you see his eye?

He looked upon you to lust after you.

I fear thee, ancient mariner.

O, Kinch, thou art in peril.

Get thee a breechpad.

Ulysses, 279

When Bloom visits the maternity hospital, he finally meets Stephen in the company of Buck Mulligan, drinking with his medical student friends. In the next episode, Bloom and Stephen go to a brothel. In this, the longest episode in *Ulysses*, written in the form of a play, Bloom and Stephen engage with each other in the dialogue. As the novel moves toward its conclusion, Bloom and Stephen go to the cabman's shelter to eat. It is there that they encounter a drunken sailor and the imposing figure of Lord John Corley. In the next-to-last episode, said to be Joyce's personal favorite, Bloom returns home with Stephen and offers him a place to stay for the night, but Stephen refuses, returning home, while Bloom makes his way to bed. Eccles Street is the Ithaca where Ulysses and Telemachus (which is which?) go their separate ways.

> Bed: A gain's wake

How does it end? With a chapter of sixty-odd pages and... practically no punctuation. It is the monologue of Homer's Penelope from the mouth of Molly Bloom, and all that the transition entails earned *Ulysses* the reputation of being a dirty book:

Ill put on my best shift and drawers let him have a good eyeful out of that to make his micky stand for him Ill let him know if that's what he wanted that his wife is fucked yes and damn well fucked too up to my neck nearly not by him 5 or 6 times handrunning theres the mark of his spunk on the clean sheet... (*Ulysses*, 929)

In spite of nightmares and grotesque illuminations of raw psychological horrors revealed simultaneously with the love-making positions between HCE and ALP, the language of the *Wake* gives an entirely different effect from Molly's monologue:

At half past quick in the morning. And her lamp was all askew and a trumbly wick-in-her ringeysingey...Tipatonguing him on in her pigeony linguish, with a flick at the bails for lubrication, to scortch her faster, faster... Three for two will do for me and he for thee and she for you. (*Finnegans Wake*, 583-84)

> In the Riddle is the Sound-Dance

Joyce wanted the picture of Dublin to be so complete in *Ulysses* that if the city vanished, it could be reconstructed from the book. An entirely different type of reconstruction, no less daunting, of thoughts and actions of characters is required to solve the puzzles that Joyce scattered throughout his text. Some may remain unsolvable forever:

What is the meaning of the postcard with U.P.: up written on it?

Mr. Breen dreams the ace of spades walks up the stairs, wakes up from the nightmare to the morning mail that makes him stare at another card bearing only the cryptic message:

U.P.: up

Mrs. Breen puts it down to a cruel acquaintance or neighbor deliberately tormenting her demented husband. But what to make of the echoes that begin three episodes later?

Something detective read off blottingpad... Poor Mrs. Purefoy. U.p.: up. (*Ulysses*, 361)

Is the detective case the upper case that has disappeared?

It later appears that Mr. Breen is looking for a detective and has been counseled to have the handwriting on the mysterious card examined. At this point, a certain J.J. (not Mrs. Joyce's Jimmy but Jimmy Johnson (close enough) states:

Of course an action would lie... It implies that he is not compos mentis.
U.p.: up. (*Ulysses*, 416)

U.p.: up pops up one more time; Mr. Breen is no closer to solving the riddle, and JJ is giving no obvious hints:

See him sometimes walking about trying to find out who played the trick.
U.p.: up. Fate that is. (*Ulysses*, 497)

But **Joyce scholars have come up with solutions that show the way of the sleuth on the way to the truth for many of the riddles in *Ulysses*.** So, for example, what might be the secret identity of Martha Clifford, who uses this pseudonym to flirt with Bloom by correspondence? Joyce might just be giving it away when Bloom selects the name Callan, ostensibly at random from the obituaries, as he pretends to Richie Goulding that he is replying to an ad. If that is the clue, then Martha may be Nurse Callan.

> A MISSING APOSTROPHE

Browsing one day at Shakespeare and Company, the Paris bookshop where Joyce was a fixture (proprietor Sylvia Beach was responsible for getting the first edition of *Ulysses* and later *Finnegans Wake* into print), I approached a display of a new edition of the *Wake*.

Another customer turned to me and said, "I tried reading that book in college... there's something wrong with it;

there's no punctuation."

Apart from no apostrophe in the title, a deliberate and telltale omission, there is much punctuation in the *Wake*, most of it completely standard.

Even so, plenty of would-be readers don't understand Joyce, but if Picasso was right, what ensures that we can?

And the missing apostrophe

(it's not Finnegan's Wake)

is a good place to start.

To be sure, there is a funeral wake, and it is Finnegan's.

But Joyce is never content with one meaning at a time.

The hero of Joyce's title is dead and ready to be laid to rest in a *mastaba-tomb*, an Egyptian tomb of stone, but it is only the fourth page of the book and Finnegan is going to begin again, as Joyce writes:

Mastabatoom, mastabadtomm, when a mon merries his lute is all long. For whole the world to see.

The echoes are all long too, and Joyce, as usual, wants his readers to see/hear them whole: the Egyptian tomb reference, the Latin phrase *stabat Mater* (the opening words of the hymn on the Virgin Mary at the crucifixion and a further echo of *merries*), resurrection and erection, and the charge of sexual impropriety that hangs over the head of Finnegan's alter ego, Humphrey Chimpden Earwicker. Elsewhere his initials stand for Here Comes Everybody—universal man—and much more.

As readers, we are quick to want to know how a story will end. It's a habit that won't do when we come to Joyce.

Does any book other than *Finnegans Wake* end with **the**?

It's really no ending at all, because the reader is supposed to go back to the first word in the book, *riverrun*, and begin again, like Finnegan himself.

One of the puns on his name is the French word fin (end):

Fin again.
Begin again.

It's the book of Dublin's giant and of double ends joined (Joyce said *Dublins Jined*) by the phrase *the riverrun*.

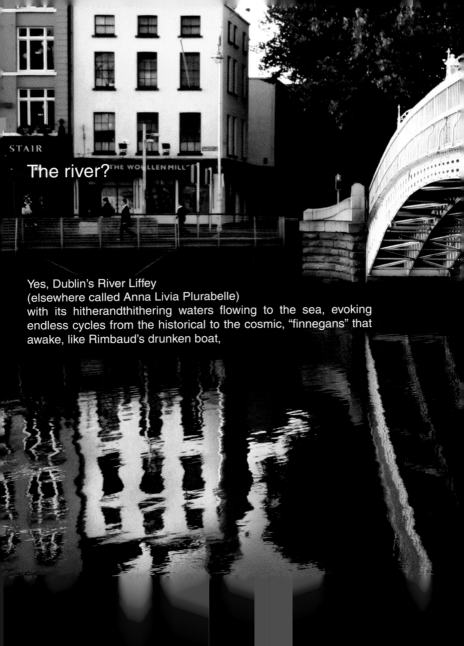

The river?

Yes, Dublin's River Liffey
(elsewhere called Anna Livia Plurabelle)
with its hitherandthithering waters flowing to the sea, evoking
endless cycles from the historical to the cosmic, "finnegans" that
awake, like Rimbaud's drunken boat,

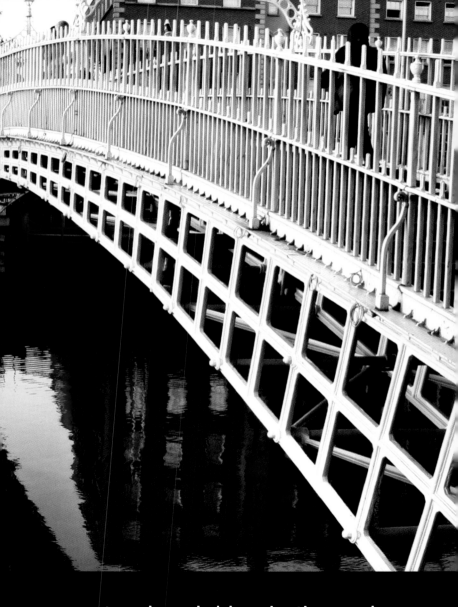

an apostrophe sinking in the wake.

Apart from the apostrophe, most of what sinks in the *Wake* soon surfaces again. The hapless hero Humphrey may be down for the count, but he is far less fragile than his echoic cousin Humpty Dumpty. Their names are linked, and both escape their fate in the monologue spoken by Anna Livia Plurabelle/Liffey on the final page of the *Wake*:

"If I seen him bearing down on me now under whitespread wings like he'd come from Arkangels, I sink I'd die down over his feet, humbly dumbly, only to wash up."

Humpty Dumpty is drawn into the unbroken cycle of death and resurrection, of end and new beginning (like Finnegan), of the river flowing into the sea, by the words

"down...humbly dumbly...up."

> One Take on the *Wake*

Not the story of Finn (Ireland's Arthur), but Humphrey Chimpden Earwicker, the tavern keeper, his wife Ann (Anna Livia Plurabelle), their sons Shem and Shaun, and daughter Issy. The family lives above HCE's tavern on the bank of the River Liffey, in the Dublin suburb of Chapelizod.

The whole of the *Wake* is set during the night, and the Earwicker family's lives are further darkened by the charge of sexual impropriety against HCE. If it happened, it was in Dublin's Phoenix Park

soul'd woman
souled women
soul omen
sole man
solomon
simmon
someone
sun men
some man
sold man
sermon

The *Wake* may not be a novel in any conventional sense, it may be HCE's dream or a collective dream, but the plot thickens all the same. A letter comes to light incriminating HCE, apparently written by Shem. But Shaun reveals that the letter is in his possession, and that Shem is not the author.

In the end, the sullied man is saved by his solid woman—not:

The solid man saved by his sillied woman. (*Finnegans Wake*, 94)

> Not is, please, the commodius vicus

That's why one take is an untake. Take, for a sample:

**The cyclical structure of the *Wake* originating
in the theory of Giambattista Vico**

Teems of times
and happy returns.

The seim anew.

Ordovico
or viricordo.

the exploration of the psychological theories
of Carl Jung and Sigmund Freud

Yung

and easily

freudened

Finnegans Wake, 115

Every letter is a godsend,
ardent Ares,
brusque Boreas
and glib Ganymede
like zealous Zeus,
the O'Meighisthest of all.

Finnegans Wake, 269

the space-time continuum

fourdimmansions...
the bounds whereinbourne
our solied bodies all attomed
attain arrest

Finnegans Wake, 367

A bone, a pebble, a ramskin...
leave them to terracook in the
mutthering pot:
and Gutenmorg with his crom-
agnon charter, tintingfast and
great primer must once for
omniboss stepp rubrickredd
out of the wordpress

Finnegans Wake, 20

...and a hundred more,
none of them entirely separate from each other,
none entirely separate from the story of HCE and his family.

> WHAT IN THUNDER?
1001 WATT THUNDER

That's why one take is an untake. Take, for a sample:

Bababadalgharaghtakamminarronnkon
nbronntonnerronntuonnthunntrovar
rhounawnskawntoohoohoordenenthurnuk

—the first thunder of *Finnegans Wake*
Finnegans Wake, 3

Samuel Beckett was right: the *Wake*, taken as a whole, isn't about
something (one thing, one theme). But certain parts of the book
are wholes in themselves—none more so than its ten thunders.
Unlike the whole of a heap of sand, containing the same old
grain again, and again, *andagrain, andagain, andagroan andagrin
andagreen andagrand andagrind anda,* these are wholes consist-
ing of unity combined with variety. And they are very much about
something—

some things and some themes.

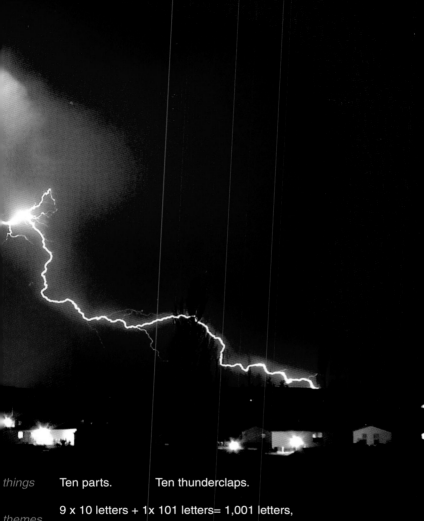

things Ten parts. Ten thunderclaps.

themes 9 x 10 letters + 1x 101 letters= 1,001 letters,

thems all in unpronounceable sequences (not surprisingly, since thunder is the voice of God, whose language we do not speak), all darker than the darkest of the 1,001 *Arabian Nights*. The Arabian light-ning under the thunderclap is both too bright and too brief to help

tens us read it.

Arabian lightning? Yes, Arabic words crammed into this first thunder of the *Wake*. It was a flash of inspiration for Joyce (apparently that kind of light never stopped going off in his head), but it can bring a dash of desperation for us, unless we take our bearings from its secondary rumbles.

These are rooted in the themes of the book and recognizable English words than can help lead us back into the thunderclap and understanding it, without first taking a course in Arabic. (In any case, the Arabic words are dancing joycly with many more from Egyptian, Hebrew, Hindi, Greek, Swedish, German, Turkish...requiring more Berlitz than the average reader can afford just to understand page one.)

As the thunder recedes and we ask, "What was that all about?" Joyce gives us echoes of it in

Upturnpikepointandplace

Finnegans Wake, 3

and

hierarchitectitiptitoploftical

Finnegans Wake, 5

Here is the entire mythic structure of the *Wake* packed into a twin volley of verbiage for the cyclical fortunes of Finn, HCE, Adam, ALP, Humpty Dumpty, the world in all its ups and downs, construction and destruction inseparably wed, bringing us by a commodius vicus (Vico's modus operandi):

from

upturn to

tiptitoploftical

via

tip

tipped it

tiptotop

tiptop

loft

topple off

plof!

lolly

topple off it

Punctuate me that, me Shakespeare shopper!

Now for those Arabic words, lurking in whole or in part, in the primary thunder, reinforcing all the humps-and-downs and many more themes of the *Wake*:

door	باب	bab
father	أب	ab
after	بعد	bad
egg	بيضة	bayda
change	بدل	badal
thunder	رعد	raad
wheat	قمح	qamh
ambush	كمين	kammin
mother	أم	umm
blind	أعمى	amma
fire	نار	nar
brick	طوب	toub

The thunder also echoes in anticipation. It is not long after we read bababadalghar...that we arrive at the Baddelaries partisans, those battlers who are inseparable from their badelaires (swords) and the suggestion of Baudelaire's *Flowers of Evil* with its theme of the Fall.

> **IT'S A WATERFUL WORLD**

If the River Liffey dominates Dublin and *Finnegans Wake*, she is
far from alone. If *Finnegans Wake* is, as Marshall McLuhan called
it, a **tribal encyclopedia**, it is also a global geography, with forty
rivers being named or referred to in the Washerwoman episode
alone:

Kennet,	Mezha,
Char,	Irrawaddy,
Ashley,	Husheth,
Saon,	Lethe,
Erewon,	Oronoko,
Hurd,	Isonzo,
Godavari,	Limpopo,
Vert,	Scamander,
Shower,	Iser,
Aman,	Isis,
Derwent,	Zezere,
Wharnow,	Meanam,
Yangtse,	Maine,
Manzinaries,	Nyar,
Ora,	Kishtna,
Orbe,	Evenlode,
Las Animas,	Jurna,
Ussa,	Towy,
Ulla,	Tys,
Umba,	Elvenland.

> THE SIMPLEST AND MOST COMPLEX LANGUAGES OF MAN SIDE BY SIDE

So said Charles Kay Ogden, referring to the text of *Finnegans Wake*, side by side with its translation into a very special language. Ogden, like Joyce, was a person of encyclopedic learning, a linguist, and a translator. He was also a collector of everything from masks and medals to autographs, art works, and a personal library of over 60,000 volumes (but this is another story). While working to develop a system of simplified English known as BASIC (British, American, Scientific, International, Commercial), Ogden invited Joyce to the Orthological Institute, his private research institute in London, to record a fragment of Anna Livia Plurabelle, as the *Wake* was known before Joyce had completed it. It was 1929, and Joyce arrived in London to make the recording. Nearly blind already, he needed to be prompted in the studio by an assistant, who managed to keep her voice from becoming audible on the recording.

Joyce had a lively interest in BASIC English. Dougald McMillan, the chronicler of transition, the journal in which Anna Livia Plurabelle appeared in serialized form, went so far as to put Ogden alongside Italian Renaissance philosopher Giambattista Vico, and French litterateur Marcel Jousse as the three most powerful influences on Joyce. And among these, McMillan claims, it was Ogden, above all, who prompted Joyce's attempt to use language as a tool for the penetration of the unconscious.

The simplest and most complex languages of man,

side by side.

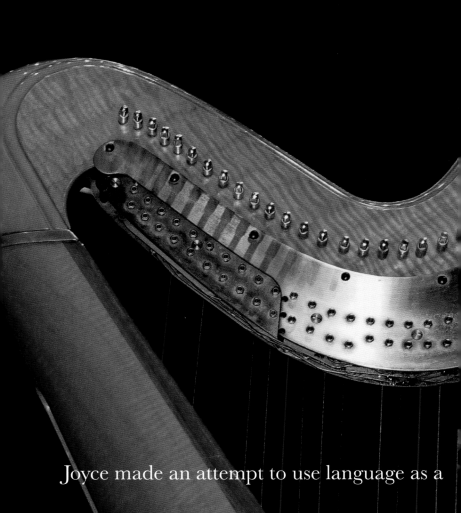

Joyce made an attempt to use language as a

tool for the penetration of the unconscious.

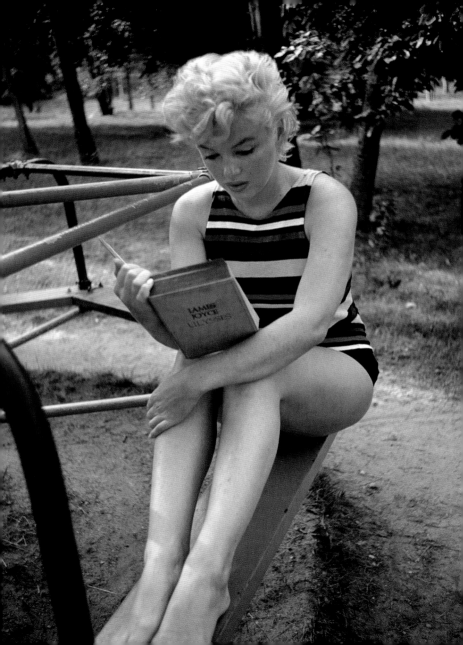

STRATEGIES

FOR

READING

JOYCE

Strategy 1:
Don't leave Joyce's words on the page. They are crying out loud to be read aloud.

Hundreds, if not thousands, of languages around the world exist only in spoken form. These languages are akin to the one that Joyce invented (he's all about invention instead of convention) to revitalize English for his purposes. He called *Finnegans Wake* his book of the night. We cannot read in total darkness, but we can speak. And we can recite from the tribal encyclopedia of the *Wake* without seeing what we are saying. No papyrus, no parchment, no paper, no pixels—no problem. In fact, an advantage, because it's the written word that can keep us in the dark, while the spoken word has the power to illuminate what Marshall McLuhan called the high dark Sierras of the mind. Especially Joyce's mind. The *Wake* is about language:

In that earopean end meets Ind. (*Finnegans Wake*, 598)

In the buginning is the woid, in the muddle is the sound-dance, and thereinofter you're in the unbewised again, vund vulsyvolsy. (*Finnegans Wake*, 378)

So ear what you can and talk it from there.

Read faster than you want to.
None of Joyce's words are intended
to be isolated, so don't isolate them.

Don't stop and ask yourself what he means by

kissmans

What's the context?

muddy kissmans

Clear as mud. So ask the same question again.
Reading faster brings us to a larger context that brings in
words that bring in help:

wish for a muddy kissmans

Along with the first strategy of reading out loud,
it's now a lot easier to get

wish for a Merry Christmas

Sure, there are more than fifty languages under the words of the Wake, but even if you happen to know the Russian language, don't go looking for it. Look for Russian dolls instead.

All of Joyce's words are like those nested dolls, and once they are apart in his hands, they dance with each other.

Read slower than you want to, after the first three strategies have helped you to open up the text.

Now you'll get even more resonances.

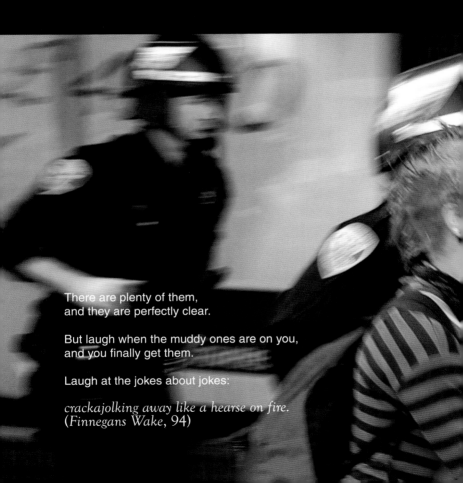

Don't let the rich complexity of joyspeak
overwhelm you and keep you from laugh-
ing at the jokes.

There are plenty of them,
and they are perfectly clear.

But laugh when the muddy ones are on you,
and you finally get them.

Laugh at the jokes about jokes:

crackajolking away like a hearse on fire.
(*Finnegans Wake*, 94)

Strategy 6:
Don't complain about the lack of punctuation.
Sometimes there is too much!

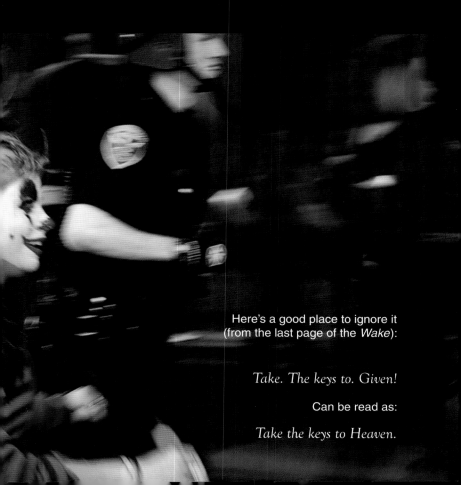

Here's a good place to ignore it
(from the last page of the *Wake*):

Take. The keys to. Given!

Can be read as:

Take the keys to Heaven.

AN ECLECTIC
ULYSSES/FINNEGAN
ENCYCLOPEDICTIONARY

111: The number of sons and daughters of Anna Livia Plurabelle

1132 A.D.: Given twice in the pre-history of Ireland that forms part of the first chapter of *Finnegans Wake*; historically, the date is of little real importance. But it is the quintessential number of the book, representing both the Fall of Adam & Co. (A falling object increases its velocity by 32 feet per second for every second of its fall) and Resurrection or Begin-Again's Wake (11 being symbolic of starting over after 10).

566 A.D.: Half of 1132. The date is linked to Blubby wares, Blurry works, and a lass who found "hersell sackvulle of swart goody quickenshoon" … and that is only half the story.

Agenbite of inwit: Occurs many times in *Ulysses* in relation to the introspective and self-analyzing personalities of Leopold Bloom and Stephen Dedalus. The phrase is archaic English, with the literal meaning of the again-biting of inner wit, but Joyce often follows up the phrase with its modern translation: conscience. Inspired by Joyce, Marshall McLuhan turned the phrase into the "agenbite of outwit," to refer to the damaging psychological effect of technology (outward extensions of the human body).

Anna Livia Plurabelle: Dublin's River Liffey is renamed in the *Wake* to incorporate the name of HCE's wife, Ann, reference to fertility (via plural), beauty and via the inititials ALP (mediated in turn by the associated visual), the eternal feminine: "Anna was, Livia is, Plurabelle's to be." (FW, 215)

Ashplant: Stephen Dedalus's walking stick, a prop carried over from *Portrait of the Artist as a Young Man* to *Ulysses*. It takes its place in the lyrical poetry of Stephen's morning at the beach and in the midnight frenzy of the brothel, where he uses it to smash a lamp. When he breaks the ashplant, Stephen has begun to liberate himself. Early in *Ulysses*, Stephen says, "My ash sword hangs at my side." (U, 45)

Ballad of Persse O'Reilly: Complete with musical score in 6/8 time and the key of A Major/F# Minor, composed by Joyce, it closes the first chapter of the *Wake*. The name hybridizes Sir Walter Raleigh, who introduced the potato to Ireland, Padric Pearse, the leader of the 1916 Easter Rebellion and Humphrey Chimpden Earwicker via the pun on the French *perce-oreille* (earwig) and a phrase in one of the numerous verses—He'll Cheat E'erawan.

Broken Eggs will poursuive his bitten Apples for where theirs is Will there's his Wall (FW, 175): Here Come Eggs? Just one. The sentence takes us from Humpty Dumpty to his fall off the wall, with much in between: Eve via poursuive, Adam via Apples, God's will and another Will—Shakespeare. In this respect, the line is a

variation on one from Stephen Dedalus in *Ulysses*: "If others have their will Ann hath a way."

Brothers: From this archetype spring the many new clichés of the *Wake*: Mutt and Jute, the Mookse and the Gripes, Glugg and Chuff, Kevin and Jerry, the Ondt and the Gracehoper, Shem and Shaun.

Crackajolking away like a hearse on fire (FW, 94): Turns the joke back on itself. But it's all feedforward and no backfire, a Möbius strip of language, like the book of Doublends Jined.

Finn: In Irish legend, the counterpart to King Arthur.

God is a shout in the street (U, 42): Stephen is speaking to Mr. Deasy, the anti-Semitic school headmaster and challenges his view of history as moving toward the one great goal of the manifestation of God. The challenge falls on ears that are deaf to shouts in the street.

HCE: Here Comes Everyman, Humphrey Chimpden Earwicker, Haveth Childers Everywhere, Huges Caput Earlyfouler, Hircus Civis Eblanensis, He'll Cheat E'erawan and occasionally flipped into ECH, as in "Etrurian Catholic Heathen," and "Eblania's conglomerate horde." HCE is also linked to that other three-in-one, the Holy Trinity, via the Gospels, delivered in HCE's own stutter: "...for the farmer, his son and their homely codes, known as eggbert, eggblend, eggburial, and hatch-as hatch can..." And there is more: "I can telesmell him H2CE3." HCE undergoes other expansions but is never shortened, and so not to be confused with the EC of *Portrait of the Artist as a Young Man*—all that remains of Emma Clery from the earlier draft of the book (Stephen Hero).

History, Stephen said, is a nightmare from which I am trying to awake (U, 42): Stephen is speaking to Mr. Deasy, the anti-Semitic school headmaster and challenges his view of history as moving toward the one great goal of the manifestation of God.

...homely Humpty Dumpty boiled... (U, 763): He is identified with HCE in the Wake (Humpty Crashing Earthward), but in *Ulysses* he is a humble egg. An egg is an egg is an egg. (Compare the three eggs in "homely codes" in the entry above for HCE.)

Johns is a different butcher's (FW, 172): John, Shaun, Shem, Shaun, John takes us via Shem the Penman to Shakespeare and via Shaun, the brother and Brawnman, to John the father of the Penman. John Shakespeare, father of William, it is said, was a butcher.

Kinch: Buck Mulligan's nickname for Stephen Dedalus. It means blade.

K.M.R.I.A.: Kiss My Royal Irish Arse (from *Ulysses*)

Mamalujo: Matthew, Mark, Luke and John, all rolled up into one. They are the old men who bear Shaun to his trial in the *Wake*.

Man in the Macintosh: One of the greatest enigmas of *Ulysses* may well be the identity of the Man in the Macintosh. He appears as the thirteenth mourner at Paddy Dignam's funeral, but he is a bit of a Halley's Comet in Bloom's day. No less a literary heavyweight than Vladimir Nabokov speculated that the shadowy figure was intended to represent Joyce himself. But there is intriguing evidence that he is a transplant from *The Dubliners,* namely Mr. James Duffy in the story "A Painful Case." There are other cases of such transplants.

mememormee: Me!me! and memory and remember me, says ALP, in the closing lines of *Finnegans Wake.* When we read the next sentence, we get more than me: Till Thousendsthee. Now the text completes and complements what precedes. Me yields to thou and thee, the multiple m of mememormee becomes the Roman numeral M (thousand) via Thousendsthee, so spelled to give at the same time Thou sendest thee, an orthological paraphrase of God's message to Moses: "Tell them that 'I AM' sent you." Given Joyce's knowledge of Dante, and the multiple transformations of language going on, there may also be a subtle reference here to Canto XVIII of the *Paradiso*, where the souls of the beatified group themselves to spell out a Latin sentence whose final letter (M) is transformed into the eagle that allows Dante to soar higher still toward an understanding of God's mysteries.

… mute, reproachful, a faint odour of wetted ashes (U, 4): The phrase occurs in the description of Stephen's mother as she appeared to him in a dream after her death. The phrase is later repeated with variations: …mute secret words, a faint odour of wetted ashes (U, 10); …an odour of rosewood and wetted ashes. (U, 33)

Now eats the vintner over these contents oft with his sad slow munch for backonham (FW, 318): By the time Joyce gets to the end of his sentence, he seems to have drifted far off course from the lines he is reworking from the opening of Shakespeare's *Richard III:* Now is the winter of our discontent/ Made glorious summer by this son of York. On the contrary, the pun-loving Joyce puts paid to York through pork: bacon and ham. Further research is not yewless: the Roman name for York was Erboracum—the place of the yew trees.

Our wholemole millwheeling vicociclometer (FW, 614): Opens a passage that summarizes Joyce's version of Vico's cyclical theory of history, applying it to literature and… the scrambling of eggs.

O yes! O yes! Withdraw your member! Closure. This chamber stands abjourned (FW, 585): HCE and ALP have climaxed in ecstasy. O yes! O yes! expressing their ecstasy also echoes Oyez! Oyez! reinforcing the legal language used to express their sex act. It also echoes Molly Bloom's joyous affirmation of sex on the final page of *Ulysses*.

Sant Iago by his cocklehat: In *Finnegans Wake* (41), Joyce fuses two Shakespearean references: From *Othello*, the villain, Iago; from *Hamlet*, Ophelia's true love, recognizable by his cocklehat and staff. In *Ulysses*, Stephen speaks of his cocklehat and staff. The fusion is reinforced by the shrine of Santiago de Compostela, with its emblem of a cockleshell.

Shem and Shaun: See Brothers.

Sign by nature and signature: So why, pray, sign anything, as long as every word, letter, penstroke, paperspace is a perfect signature of its own? (FW, 115), a link to Stephen's observation as he is strolling the strand in the third episode of *Ulysses*: Signatures of all things I am here to read. Here is the groundwork of semiotics crushed into a few word, echoing the crackling wrack and shells beneath Stephen's feet. Everything is a representation of itself, a signature of itself, before it becomes a sign of something else. The work of the semiotician and the writer as artist begin with this apparently endless potentiality. For the reader, it creates a level playing field where meanings are made instead of matched to prepackaged knowledge or symbolic systems of any kind.

... sometime regius professor of French letters to the university of Oxtail (U, 13): Thus spake Joyce of Zarathustra. French letters refers to condoms.

Symbol of Irish art: When Buck Mulligan holds up his shaving mirror to force Stephen to look at himself, he discovers that it is cracked and calls it the symbol of Irish art. (Later Stephen and Bloom will look in the mirror together and see the image of Shakespeare.)

Tear-nan-Ogre: The Irish land of the afterlife.

Thing: What a difference an upper case makes. This is the name of the Norwegian Parliament. The hill where it was held in Dublin is now called Suffolk Place. ("Our Norwegian Thing-seat was where Suffolk Street is." Same Thing in the *Wake*: "Northmen's thing made southfolk's place..." (215).

To have or not to have, that is the question (U, 663): Stephen, frequently identified with Hamlet, proceeds no further than this with his version of the famous soliloquy.

verytableland of bleakbardfields (FW, 10): The bard bit is a tip-off to a riff on The Bard: Shakespeare. The phrase is an echo of a line referring to the dying Falstaff in *Henry IV*, Part 2: "and a babbled of green fields." In the Folio, the line reads "and a table of green fields," but the emendation has come to be accepted.

Viel Uhr? Filou: The story goes that during World War I a German soldier on one side of a river asked *Wie viel Uhr?* (What time is it?) and the reply came from a French soldier on the other side *Filou toi-même*! (Filou, yourself!) Joyce adapts the exchange in the dialogue between the washerwomen in *Finnegans Wake*.

Waterhouse's Clock: Dublin's Big Ben. The name of the renown clockmaker Waterhouse is used in reference to any important person. The first builder of Dublin was a Viking, Deucalion, the Greek word for water-house.

Which goatheye and sheepskeer they damnty well know (FW, 344): A triumvirate of literary giants. Read "...which Goethe, Shakespeare, and Dante well knew." Later they are referred to as Daunty, Gouty, and Shopkeeper. (539)

Who ails tongue coddeau, aspace of dumbillsilly? (FW, 15): A rare example of a complete and grammatically correct sentence from French transposed into the *Wake*'s Eurish language: *Où est ton cadeau, espèce d'imbécile?* (Where is your gift, you imbecile?)

You said, Stephen answered, O, it's only Dedalus whose mother is beastly dead (U, 8): Stephen addresses the reproach to Buck Mulligan, who at first does not recall having said it but then apologizes for having offended the memory of Mrs. Dedalus. Later, in a dream sequence, he speaks and again uses the offending epithet beastly dead (U, 681).

You were dreamend, dear. The pawdrag? The fawthrig? Shoe! Hear are no phantares in the room at all, avikkeen (FW, 565): ALP awakens Shem from his nightmare to assure him that there are neither fantoms nor evil fathers in his room.

BIBLIOGRAPHY OF BOOKS DISCUSSED WITHIN THIS BOOK

Joyce, James. *Dubliners*. New York: Penguin, 1976.

_____. *Exiles*. London: Jonathan Cape, 1952.

_____. *Exiles: a play in three acts*. Harmondsworth: Penguin, 1979 [1951].

_____. *Finnegans Wake*. New York: Penguin, 1992.

_____. *Poems and shorter writings*. (Richard Ellmann et al., eds.) London: Faber, 1991.

_____. *Pomes penyeach and other verses*. London: Faber, 1966.

_____. *Portrait of the Artist as a Young Man*. New York: Penguin, 1992.

_____. *Ulysses*. New York: Penguin, 1992.

McMillan, Dougald. *Transition: The History of a Literary Era 1927-1938*. New York: George Braziller, 1975.

IMAGE CREDITS

EVERYMAN's JOYCE
by W. Terrence Gordon, Eri Hamaji & Jacob Albert

Design: Eri Hamaji
Image Selection: Jacob Albert
Text Editing: Buzz Poole

Library of Congress Control Number: 2007937352

Printed and bound in China.

10 9 8 7 6 5 4 3 2 1 First edition

This edition © 2009
Mark Batty Publisher, LLC
36 West 37th Street, Suite 409
New York, NY 10018, USA.
www.markbattypublisher.com

ISBN: 978-0-9795546-8-1

Distributed outside North America by:

Thames & Hudson Ltd.
181A High Holburn
London WC1V 7QX
United Kingdon
Tel: 00 44 20 7845 5000
Fax: 00 44 20 7845 5055
www.thameshudson.co.uk